Marie-Fra...

Raphaela...

OUTSIDE
FORM

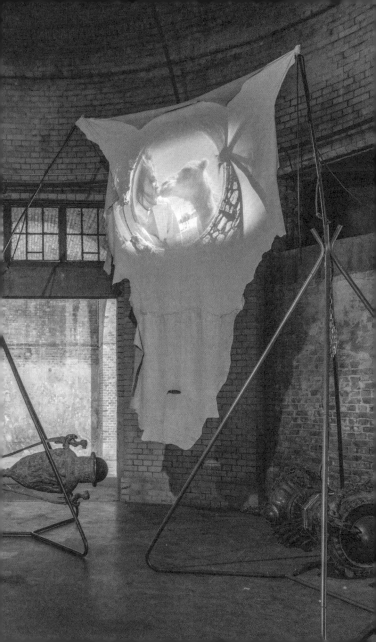

Raphaela Vogel's works are versatile and multilayered. From her large-format paintings, sometimes painted on animal skins, to her expansive sound and video sculptures, the artist investigates art's boundaries and capacity for resilience, its institutions, as well as the visual and aural habits of its viewers. In her partially contorted and cross-faded image-worlds, in which she disorients genres, one sees the figure of Vogel striking out her own path in spherically circling movements, occupying space and asserting herself within it. It would, however, be wrong to say that her works are most concerned with the artist herself. Rather, these decentered and distorted images represent a general act of faltering. We falter through the different role assignments and gender-specific relations of our *conditio humana*, which are constantly pushing us to the margins, impelling us to find our center (again). But the *conditio animalis* is also central to Vogel's work, particularly the differentiated forms of relationships between humans and animals.

But where should we begin with all of these considerations so as to describe and grasp Vogel's oeuvre? Probably in the act of faltering itself, in which she places the art as such. Strictly speaking, it is primarily the aesthetic attributions (of genre) that the artist brings into disarray, as she plays with the displacement of various reference systems within the sphere of art, which she simultaneously makes visible and allows to become part of the work. This happens not only with her video sculptures and presentations, but also with gray zones (both the white cube and the black box), as well as her site-specific arrangements of work that one struggles to categorize as site-specific. This is less about an either-or and more about an active process, the setting-into-motion of limits, such that a complex whole emerges from a multiplicity.

Up and down, up and down, up and down, up and down, up and down, up and down, up and down …

In a movement that doesn't want to end, a video image projected onto the wall goes up and down while also pro-jecting an image of a rotating and deconstructing image of the artist interspersed with a recording—throbbing in and out of the foreground—of a baby in a cradle. The deconstructed digital rendering of Vogel standing in the middle of an equally fragmented, 360-degree 3D scanner is being continuously modified via mouse clicks in the image editing program. The movement of the projector, meanwhile, mimics the movement in the video and is generated by a complex construction: a colorful children's spring cradle mounted onto a tubular steel frame that bounces the projector vertically. The speakers are attached above this, with their cables, as well as those of

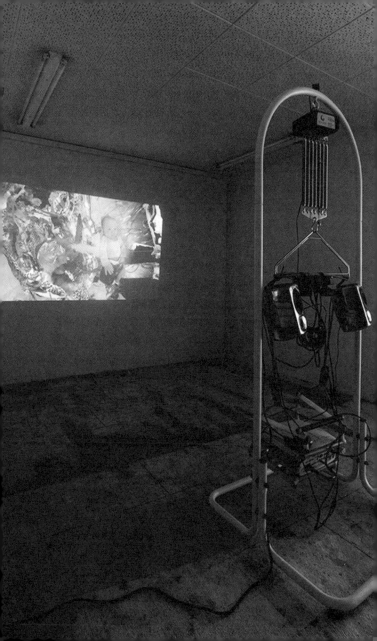

the projector, dangling down. Free-standing in the space, the unruly-looking creation displays typical Vogelesque sculptural features but, in this case, has an even stronger do-it-yourself character. Due to the rhythmic movements and the sound of the tension springs, which call to mind the ticking of a metronome, there is something disturbingly animistic about the sculpture. No less unsettling are the images in the video itself, of the artist's likeness being taken apart. Again and again, more and more pieces are removed from the figure in the grid of the black screen, which rotates around its own axis in all directions. Time and space seemingly dissolve, or, put otherwise, we are dealing with the image of a complex time: the temporality of the image is no longer bound to a determined space and time (or even historicity). This becomes clearer when the cropped-out baby that is superimposed upon the figure enters the video. Like a pulsating heart of new life, it beats in and out of the figure and heralds a new era. A moment of deferral is created, which allows other relations to emerge that are no longer linear and decryptable, but rather point to the complexity of the emotive connections.

The *Herzenskind* (the child-as-beating-heart) keeps on beating, and slowly one can hear the first piano notes of the song "Der Mann, der rückwärts spricht" (The man who speaks backward) by the German punk band Die Kassierer. With the start of the lyrics, the image changes as well. It's still the artist's own bouncing baby—her first child—though the infant has changed clothing and is now being recorded in a domestic scene from above in his hanging feather crib. The moment of relocation remains central here, but what is at stake is the suggestion of

a deferral, or a change, in perspective. This displacement is not intended solely to reveal historical-aesthetic mechanisms. Rather, what is at stake here is more one's own position as a subject, reflecting on a larger, more complex interaction of dynamic relationships.

The song goes on and the man speaks backward, embodied in the video by the child's father (the partner of the artist, Diedrich Diederichsen). Playing the video backward, one would hear: "I'm not speaking backward at all; rather, you are the ones who are speaking backward." Speech oriented in reverse is often connected to the notion of subliminal messages, particularly in the realm of music, where it is known as "backmasking." In Vogel's video, the hidden message seems to convey a mutual nonunderstanding and a general sense of being lost—or, in other words, the knowledge that everything is in motion, changes, returns, and mutually influences everything else.

Faltering returns here again, induced by Vogel's more specifically dizzying recordings: in one spherical panorama, we see the artist in a white robe towering over the child, who is laid out upon a lamb skin, surrounded by bookshelves. The camera zooms in onto the haloed baby, who is encircled by a flock of angels, before racing upward, threatening to leave the geometric space and revealing an oversized, Minerva-like Vogel. Then, both the camera and Vogel descend once again toward the child of worship: coming back down to earth, as it were. To conclude, there's a picture of an elephant, which moves in time with the metronome—a common behavior of elephants that are kept in captivity and/or have been separated from their mothers too early, thus removing

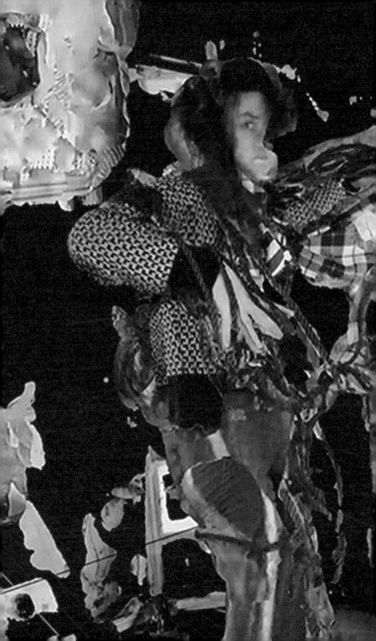

them from their sociality, comparable to hospitalism in humans. If the video were to have a narrative, which it doesn't really have, it could be said that, as a keeper of knowledge, the Minerva-like Vogel lays down her understanding at the feet of the baby. Or, perhaps she would like to communicate language as the key to knowledge and to the world, knowing all the while that there is no such thing as generalized knowledge, but rather only a process taking place within a work whose kernel consists in the entanglement of heterogeneous temporalities and anachronisms.

Der Mann, der rückwärts spricht is emblematic of Vogel's artistic practice, which itself plays with a mixture of different aesthetic elements and diffuse traditions in order to disorient viewers, a disorientation that demands a shift in the perspective toward art itself as well as existing social and cultural attributions. Indeed, Vogel's art is informed both by our cultural psychology and psychoses. In its balancing of art itself and its border (ascriptions), it demonstrates the complex nexus of anachronisms, presents, and future orientations that determine our existence. Her work is determined not by a beginning, nor an end, nor a goal; rather, it suggests a complex faltering within rhizomatic structures, repetitions, and culturally bound symptoms.

This interview with Raphaela Vogel illuminates the rich oeuvre of an artist who plumbs the depths of material, power, and inner tensions within the art(ist). In the conversation, Vogel elaborates on her practice and reflects on the complex relationship between time and space. Through the discussion, the reader can discern an artist

thinking through how one might give expression to a multitude of contradictory tensions, within oneself as well as within the genres and spheres of art.

Marie-France Rafael

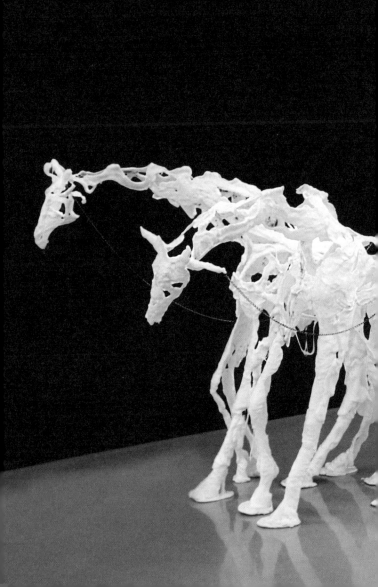

Marie-France Rafael:
I'd like to begin our discussion by speaking about one
of your new works: *Können und Müssen (Ability and
Necessity)* (2022). The work consists of a large
anatomical model of a flaccid penis that is being carried
along by a group of giraffes. It appears to be a perfect
complement to one of your older works, *Uterusland*,
from 2017. There, we have a similarly large model,
but of a woman's breast, which shoots milk and
creates a powerful, reared-up horse in front of it—a
display that moistens the entire room both materially
and metaphorically, a taking-over of the room. I'd be
interested to hear how this work came about. It would
also be interesting to hear about *Uterusland* and
confront the question of the relation between sculpture
and video later. But first: How did this new work
come about?

Raphaela Vogel:
I developed it for the exhibition *Mit der Vogel kannst du
mich jagen* (You can hunt me with the bird) in Galerie
Meyer Kainer in Vienna in 2022, and, as you've noted, it
emerged as a counterpart and antithesis to the *Uterusland*
installation. This time around, the male gender is fore-
grounded. An organ is enlarged in this work as well in
the form of a massive model, and a moment of transition
between inside and outside is portrayed. The skin operates

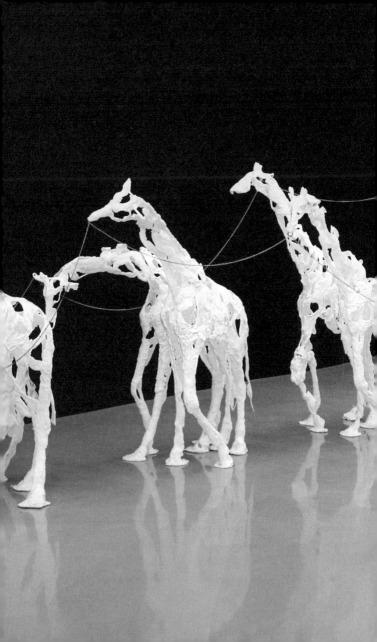

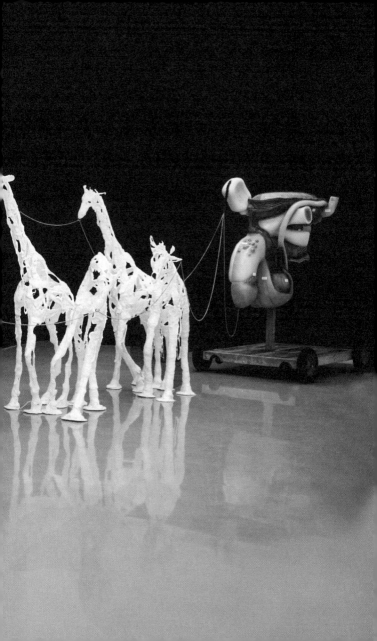

in this way as a division between inside and outside. In *Uterusland*, it's the milk that leaves the body: it sprays the horse in an off-white stream. In Vienna, on the other hand, it is urine that, in the form of a brass chain, comes out of the model directly and sprays the giraffes, which could also be read as a kind of sperm. The casts of the objects are made of the same material as the horse from *Uterusland*. The giraffes pull the model, which is placed on a wagon with wheels. To me, this is reminiscent of a Roman chariot. In contrast to *Uterusland*, in which the horse and the breast have balanced each other out more— in that it's not clear whether the horse pulls the breast or the breast sprays the horse, which wouldn't be able to stay standing without the breast—here, energy is primarily emitted from the giraffes. In *Können und Müssen (Ability and Necessity)* I have replaced this logic of a mutual balancing-out with one of an unequivocal ratio of energy.

With *Uterusland*, I had the impression that a very affirmative gesture was being exhibited: it was centered around this breast, which created the wild, rearing horse. But *Können und Müssen (Ability and Necessity)* seems to foreground a diverging gesture: the giraffes have to pull the wagon with the flaccid penis forward. Though we're still dealing with an occupation of space, this time it's as if from a fallen gladiator who is being dragged out of the arena. I also find it interesting that you consciously choose not to show these works together; in other words, you've decided not to display them as explicit counterparts. This makes me want to know more about how you would describe the main proposition, or essence, of *Können und Müssen (Ability and Necessity)*.

I wouldn't describe it as unambiguous at all, because it's
so much about the interplay of the different elements
in the space. On the one hand, we have the penis—I say
"penis" and not "phallus"—which can suffer from many
illnesses, all manner of ulcers, sexually transmitted
infections, prostate cancer, polyps, and bladder problems,
and which can even require a penis pump to get an
erection. The penis is no longer capable of "rearing itself
up" on its own. On the other hand, we have the giraffes,
which hold up their necks in a variety of ways. This
is an illustration of a morphology of gender that rises and
falls: a sequence of movements. This is something I use
more often in serial sculptures, wherein a movement
is expressed within a sculpture throughout its various
stages of development, as it changes and morphs. In this
regard, I'm simultaneously interested in the charged
relationship to cinematic representations—as in, the
tension between sculpture and (cinematic) movement.

> And in the video *Für uns* (For us), which could be
> seen in the same exhibition, we then see you "relating
> to yourself," and also, in one moment, squatting and
> peeing …

… in the work it's not so clear: you can only see the behind
of someone who's peeing. In turn, the motif of the peeing
penis is taken up again, but more of a womanly peeing,
which happens while squatting. The stream of urine
forms connections, in turn, to various other video works
of mine (e.g., *SPA*, from 2013, and *Mogst mi du ned, mog
i di*, from 2015), in which the stream or the act of peeing
is addressed as either a form or an element.

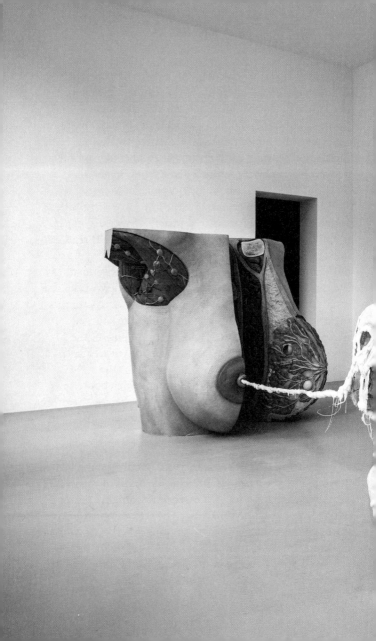

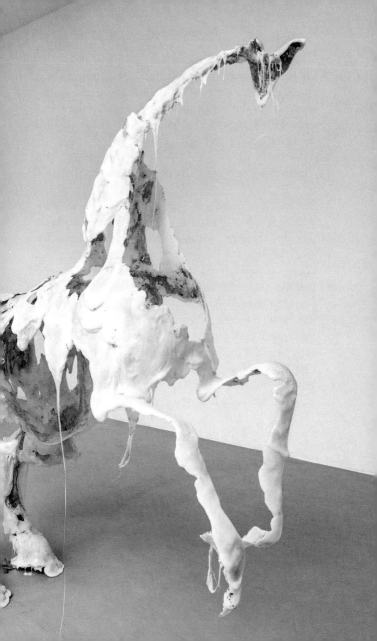

Or even as a subversive gesture, especially when you
think about its feminist connotations—such as, for
instance, in the performance and action art of the
early 1970s, in which women publicly urinated—like,
for instance, Carolee Schneemann.

Yes, exactly, because typically women don't do that.

The motif of urine is inflected into various forms in
your work. In *Uterusland*—and correct me if I'm
wrong—there are, for instance, different installations,
or rather ways of presenting how you place the
sculpture in relation to the video: for one presentation,
you use an actual urinal, in which the video work can
be seen through the flow of water. In the work, you
can be seen slipping down a water slide in one flowing
movement with a baby doll in your arm. One could
even say that you're bringing yourself into the world
as a mother figure, as an artist, even in this very
voyeuristic reference to Duchamp, as a subversive
gesture in this male urinal.

It's a meetup spot for men, as I always say.

What do you mean exactly?

A meetup spot for men, since many men can urinate there
at the same time. There are two constellations of the video
in which I slide, as it were, through a birth canal with a
baby doll: one version in relation to the breast model, and
one in constellation with the men's room.

Can you tell me anything about how this clash,
or dichotomy, comes together? On the one hand, we
have this flowing along the water slide (this metaphor
of bearing oneself), and on the other this enactment
in space, in this very specific meeting point for men.

Yes, it has different forms. As a part of the installation
with the breast, this movement seems to be directed
inward—like a slippage into the inner parts of the body.
On the other hand, the association with the toilet is
apparent, as if one were flushing something down the
drain. There are just these two sides, but I wouldn't show
them simultaneously in the same exhibition. I take
liberties with them, so that the video acquires different
connotations in different contexts.

In both cases it's a slippage, and there's also of course
the nuanced significance of a body sliding through and
in institutions.

Could you describe in more detail this aspect of sliding
through institutions, or, put differently, of being
"flushed out" through the institutions as an artist?

Well, it was the thought that underlay the work when
I planned it for the exhibition *Produktion: Made in
Germany*, in Hannover in 2017. You don't want to identify
yourself one hundred percent with such a title; rather,
I wanted to give my viewpoint on it, comment on it,
problematize it, even turn it around.

At the time, I had gone from almost no exhibitions to
quite a few, and I wanted to start dealing with that as
a topic of discussion. I wanted to reflect on how, in this
way, you slip through and are under a certain pressure

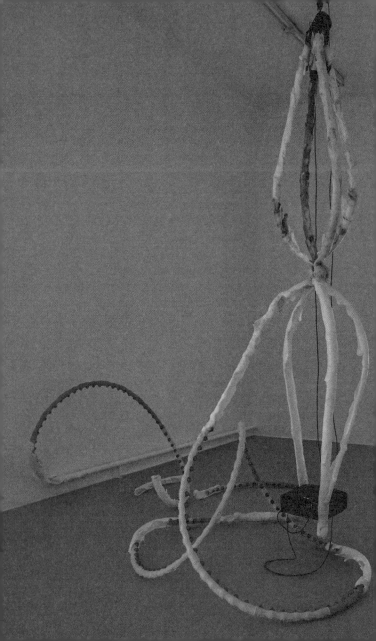

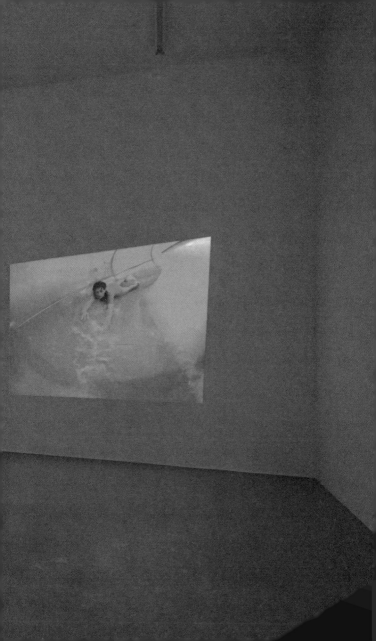

to stake out claims, how you have to make certain gestures.
I then tried to address this pressure in a few other
installations, as well as in my exhibition at Kunsthalle
Basel, which was called *Ultranackt* (2018, Ultranude). The
title is an invention; the word derives from the "Ultras"—
I mean here the football hooligans—and stands in for
a kind of image of an abstract form of pressure that
burdens someone. It was an important time for me to do
such an exhibition in a big institution. That's now changed
a bit in recent years, which could also be because I've gone
through all this different taking-up of spaces. I've played
through all of the forms and also all of the possible types
of spaces that interested me, because I had the fortune
to be able to exhibit, in a very short time, in a lot of very
different institutions and architectures. In this regard, the
topic of my work has now changed somewhat.

> That sounds exciting, because of course the question
> of pressure, as you've already noted, was very
> prominent in your work for a while. On the one hand,
> you challenged the institution itself with works like
> *In festen Händen* (2016, In firm hands), where you
> took stock of what kind of pressure a building or
> an institution can bear. On the other hand, your works
> also broach the question of societal pressure (e.g., from
> a peer group) and of a pressure exerted (by means
> of social elements) on oneself (e.g., as a young female
> artist). Your works often involve you, and in times
> of social media and selfies one could argue that yours
> is a self-referential project. But your work often
> foregrounds a self-reflexive moment. I especially get
> the impression that you pressure and push yourself
> (and also the viewer to some extent) to the margins.

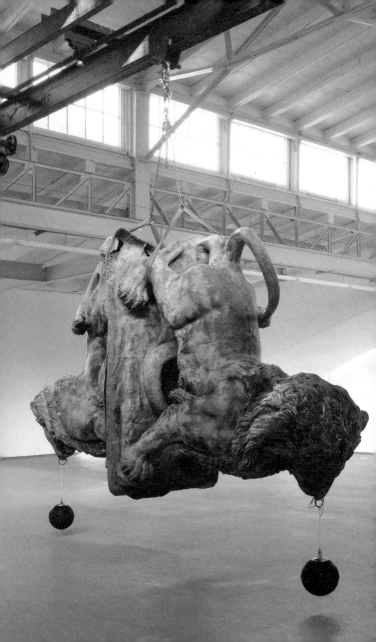

When viewing your work, I often get the feeling
of moving unsteadily, of staggering, of something
dizzying—also because this is the framework you
operate with. It's as if a subjectivity were being shown
and at the same time sent into a tailspin, like an act
of fractured self-questioning—because I sometimes
have the brief inkling that I know who Raphaela Vogel
is, and then I don't know anything about that person.
It's as if you were constructing a figure that you play
with in your work and that threads itself through
your pieces, or rather that you to some extent "flush"
yourself through your works. Can you say something
more about this?

What you've mentioned is an important topic and
a foundational question: How is the self or one's persona
anchored in the world, and, furthermore, how is it figura-
tively anchored to the installation or the image? How can
one show this—the insecurity and instability that go
along with it? And what kind of constructs are needed
to avoid becoming merely exhibitionistic? I am interested
in such questions.
 It is not always about me, but much more about an
insecure material—whether biographical or not—for which
I first have to generate a structure within the space before
anything can be established or claimed in an art-historical
or art-referential way. I need the architecture to serve
as a bracket if I'm going to be able to "perform" at all.
Either I build these structures by myself in the space,
or they emerge from the context—for instance, in the way
that the film alters the sculpture in the course of its
cinematic time and in the way the sculpture frames and
gives stability to the film. This is an important aspect

of my work, and in recent video works this focus has been displaced somewhat, as I've given more space to the sculptural. For example, I'm interested more in questions around volume, as volume is an aspect and basic parameter of sculpture. I also engage with classically sculptural questions, such as the temporality of sculpture, volume, and weight. A balancing act emerges in combination with the film: between the film, or the light element and immaterial level, and the object, or that which is heavy. This relation or "short-circuiting" between sculpture and film is the point of departure for my installations. The sound, which I've recently placed strongly in the foreground, is also a determining element of my work. In the gallery exhibition at Meyer Kainer with the penis model and the giraffes, you see in the first room a sound sculpture (*Für uns*), which on the aural level guides you into the video work, which then takes place two rooms later, with another sculpture in between, at the very end of the gallery. An autonomy emerges in the space, or rather sculpture's own time domain, because in any case one needs time in order to grasp sculpture, by walking around it. In my recent works I've attempted to explore how sculpture can function depending on sound.

This relationship between sculpture and film (in space) is not easy to grasp in your work. There are also elements that arise and transform from one installation to another—for instance, it seems to me that the water, this "being flushed down," is a recurring motif in your works, as if your works were themselves "in flow." I would be interested to know what your working process looks like. Can you briefly describe how you conceive of your pieces?

Yes, one would maybe think that the works are rather
thematically arranged, since it seems they can be located
quite strongly within certain discourses. But that's not my
primary interest nor my general approach to exhibitions;
rather, I'm interested in a structure, or the attempt to
create connections. The water and the ways in which it can
be transformed within the works were, as a sort of infra-
structure for the film, a good counterpart to the chrome
rods in the installation. I actually have this idea of a
structure or a netlike system made up of different modular
and adjustable lines and elements. For example, there is
the modular rod system that connects everything: chrome
pipes that reemerge as elements or moldings—out of
recyclable plastic, for instance—which continuously get
melted and built back up again (unless the work gets sold,
but it nonetheless will have this recyclable moment). The
chrome pipes get built too; they have a modular system
and can be built up and together again. They can be
adjusted to differing lengths in a space. I don't really like
to set anything in stone; I'd rather keep things adaptable.

What I find so exciting about your installations and
artistic displays is that they are neither pure sculpture
nor pure film in the way that you put them together;
they correspond more to film-sculptures that continu-
ously kindle an interaction between both discourses—
that of sculpture and that of film. It's as if these dif-
ferent institutionalized, art-historical discourses were
being linked together, overlapping or even subverting
each other, in order to open up a new, third discourse.
It seems to me that this third discourse is highly con-
cerned with the question of temporality, or even with
the total dissolution of a notion of measurable time.

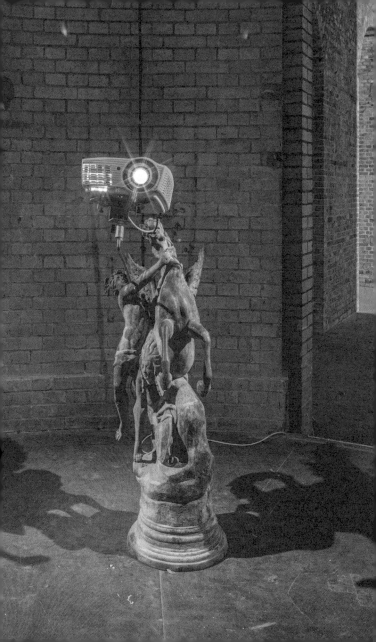

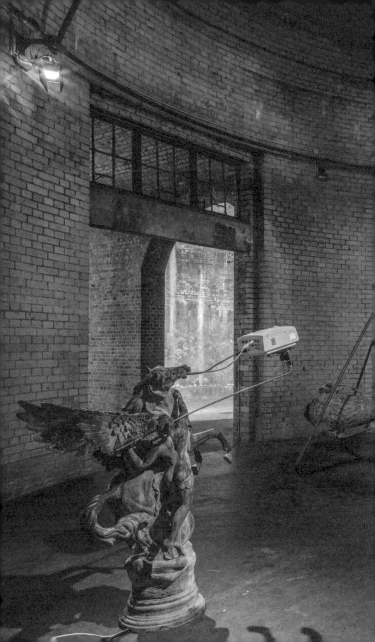

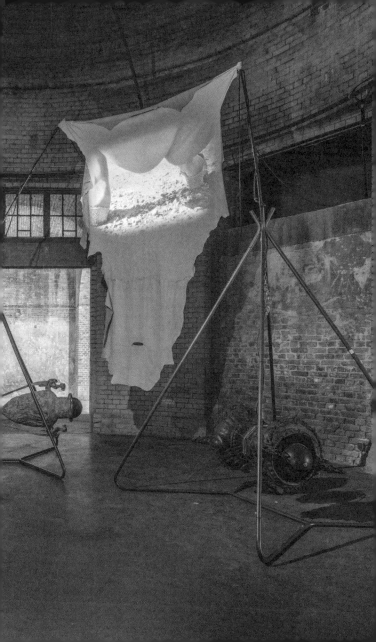

It's in this regard that, for me, this moment of flow comes in again, which reminds me partly of our post-digital age, characterized as it is by our simultaneous inhabitation of different timelines: we surf the web on our smartphones from site to site and procrastinate while, at the same time, we are under constant pressure to be productive, feeling almost "thrown" out of time.

In your work you create a comparable moment through the interaction of an architectural superstructure and the sculptural components, but also in the videos themselves, in which you use new technologies, whether drone recordings or the distortion and manipulation of images. Can you describe this moment somewhat more precisely, or rather how you come to these almost entropic spaces, to these images?

I try to play the elements against each other, mutually. What is temporality within sculpture? For instance, in the work *Son of a Witch* (2018), which was originally shown in the Berlinische Galerie, I nested two differently constructed storage tents inside of one another—in other words, I assembled two places into one architectural unit. This is actually a cross-fade, a cinematic trick, which generates such an overlapping of temporality. It's similar to how, with the video in *Uterusland*, there's an overlapping of temporality due to the simultaneous staging of a number of births—of a baby, of a mother, or, as you've already addressed, of a mother-artist figure. How does one attain this kind of simultaneousness, which can be so easily represented or emphasized in film, in the sculptural realm?

But your question was aimed more toward …

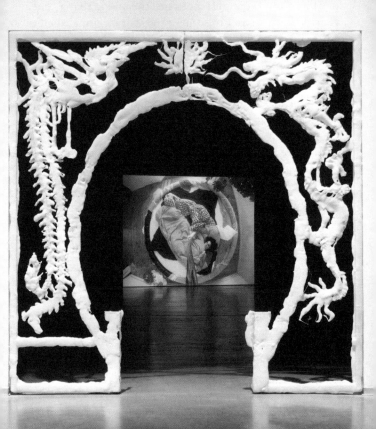

The relationship between space …

… and time, yes. For me, the exhibition itself functions
as a kind of walk-through film. The idea of the cut,
of film editing, is important to me: the notion that a "cut"
is made from scene 1 to scene 2 and that meaning emerges
from this. It might be called an "assemblage" or "instal-
lation" in a space, but in the context of an exhibition I'm
interested in the succession—a sequence of rooms that
you can walk through in time but that also parallels the
cinematic idea of creating meaning through editing—and
translating that into the space.

> You've anticipated my question, because I want
> to touch on the montage element of your installation-
> based displays. I have the impression that you subject
> your spaces to a montage like those in your films:
> to a principle of montage that generates relationships
> of tension or, as with Sergei Eisenstein and the concept
> of collision, works toward a buildup of conflicts and
> contrasts.
> Do you think about your exhibitions as you do your
> films? And are your exhibitions not perhaps, in the
> classical understanding of a cinematic narrative, more
> filmlike than the films themselves?

Yes, that's right, especially on the dramaturgical level.
Fundamentally, it's a classic *Erzählmaus* [a narrative arc
explained via a drawn mouse], as I always say. One is
slowly introduced, there's the climax, and then the
denouement—so it's this kind of suspense, the simplest
form of dramaturgy, within which one can generate more
complex narratives. I think it's good not to work against

the space, but rather to utilize to the maximum or think about it in different ways, for instance with the questions: Where are the high walls? Which walls are the viewers likely to walk along? It's important to me that everyone thinks *with* everything and doesn't work against it, rather going with the space's energy.

The films operate, then, in differing ways within the space; for instance, they can have fragmented characteristics, or function as a kind of loop. Some of my installations have an imagistic character, while others unfold more as a narration. In the best case, I try to combine or coordinate these elements, or allow them to run their course in a coordinated time frame, so that the viewers are somewhat directed as to where they can look.

Your exhibitions unfold, as you describe, an entire spatial construct. But I would also like to touch a bit more upon the previously mentioned aspects of confrontation, collision, or even conflicts in your films. Above all, I'm interested in your use of technologies, which, in your works, I often see accompanying the staging of different regimes of looking, or rather the enactment of a disembodied gaze. They also accompany the confrontation of a male and female gaze, or rather your "female" adaptation of that which can be seen as a male gaze. In this regard, I have the impression that you often make use of certain aesthetics from the 1970s, primarily from feminist art, if one thinks of female artists such as Joan Jonas and Rebecca Horn. At the same time, you reflect your own personhood—as an artist, a woman, an artistic figure, an author, a storyteller—and its agency in our contemporary pressure- and conflict-laden society.

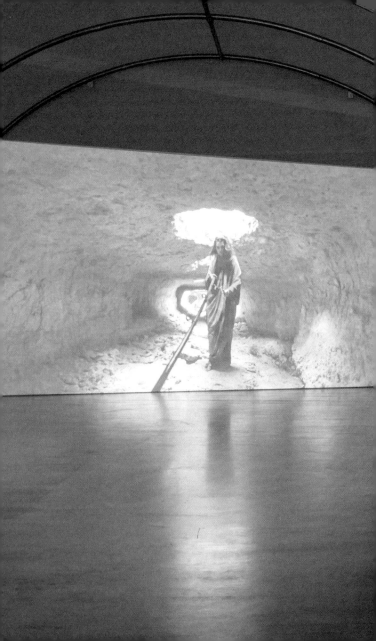

Can you describe this element of your work a bit?

In order to make a work about regimes of looking or
technologies, it's important for me that everything is done
by hand—that I can also make everything myself. So, I'm
the camerawoman, I play the persona, and edit everything;
I don't hand anything off to anyone else. Everything
comes together into one person, and I also have great
admiration for figures such as the actors Rowan Atkinson,
Adriano Celentano, Charlie Chaplin, Louis de Funès,
Jerry Lewis, or Charlie Chaplin, in whose work all of the
collaborative functions come together into a single author
(in this case, they were nearly all men). It's a handicraft
and very much connected to know-how, as well as to the
adoption of techniques (such as learning to fly drones,
produce sounds, etc.), which I approach as a nonexpert.
Because, for me, it's not so much about thoroughly
designed objects, but rather about aiming for the strongest
effect possible with the least amount of effort—in other
words, it's about an economy of effects, which emerges
not just from the effects themselves, but also through the
tension between them and the tools that are used to
generate them. This economy also entails freedom and
room for play, which viewers can experience, which is not
acted out through force but rather from this space of
flexibility. But for this, sometimes one needs to accept
other kinds of restrictions. It occupies areas of my private
life, but I think this is a good thing.

Has it always been like this? Was there a moment
in which you said to yourself: "I want to become an
artist." What brought you, then, to art?

I can't say exactly. I think I've always had fun with the creation of structures, with the moving-around of furniture and objects. When I was a child, I built rabbit hutches and was always drawing frames or plans for the renovation of our house. At the beginning of my studies at art school I was concerned with the question of where I should begin. You can do anything, but what are you allowed to do? What do you actually want to do? And what do you not want to have anything to do with? It was really about a negative perspective of the art world: when it came to what others were doing, I wouldn't or couldn't have anything to do with it. How I came to what I do happened primarily by trying things out alone.

> You often stage yourself in your works standing alone in a field. Can you say anything about this? Or how you come up with these specific "settings," which oscillate between postapocalyptic sci-fi landscapes and reminiscences of landscape painting that recall German Romanticism? What role does the landscape play for you and in relation to you, or rather to your artistic persona?

Yes, I'm interested in stages, so scenes, in Karl May–type settings that you get into somewhat by accident, and sometimes not so accidentally. For Arno Schmidt, these landscapes were erotically infused and represented gay fantasies of male bodies. For example, I filmed a significant video work—*Mogst mi du ned, mog i di* (2015), which also involves peeing—in Carrara, a long-established marble quarry from which Michelangelo sourced his marble for his *David* statue. This setting suggests, of course, the centrality of sculpture and material to the work. But it was

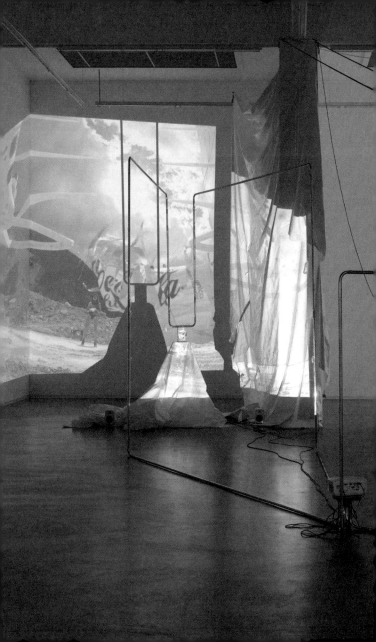

also crucial for me to set up and sound out a monumentally pathetic stage, which I can do there with a technological device: a drone. What are the means to do this? In this marble quarry, where there is a lot of space, I attacked myself with the drone, so that I always had to evade the device. I countered the drone, which was aimed against me, with a galloping horse: just as a Pegasus flies, so does the drone gallop through the sky and then continuously swing closely by you. I am often concerned with a pathos of landscape, even in its unassuming corners, such as, for instance, in the swimming pool or in the village with my mother in the field. I'm mostly interested in seeing what kind of a place that is and what I can do there with the technological device that I have with me. The theme of the control of this device, that is, of the camera/drone, is therefore very important to me—not merely in the media-referential sense, in that, à la Godard, it only gets shown and you say, "Okay, here comes the team into the picture"—but rather in the sense that it becomes a truly narrative component of my entire story. My thinking often derives strongly from physical material.

The question of material seems quite important to me, since the questions I've raised about collision or confrontation or the conflict between people and technology also come into play here: What can you do with the drone? What does the drone do with you? What does it mean to evade a drone? Do you also see this as a subconscious moment of tension that constitutes the times in which we live? You were also saying that you bring a lot of your private life into your work. So, the question becomes: To what extent does this remain private? The question of locating

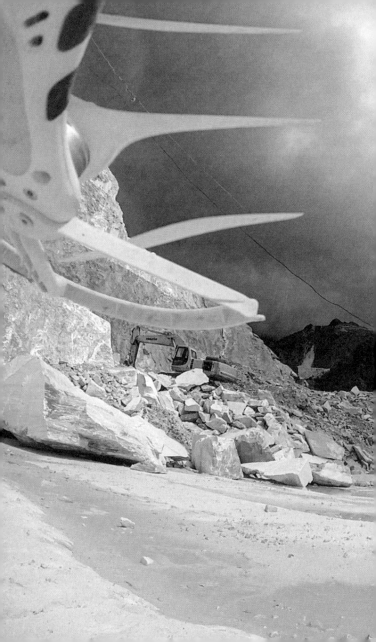

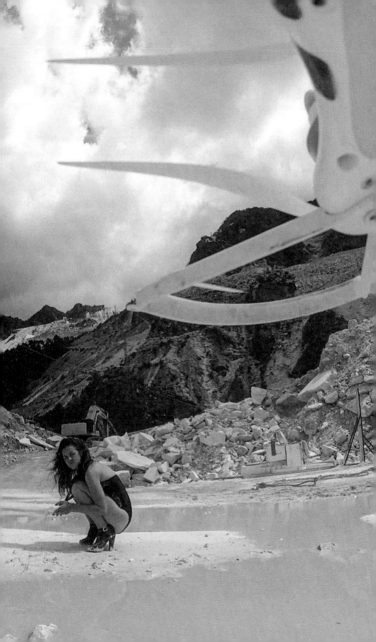

oneself within a society also comes up. Does this also come into play for you, or would you say that these are unconscious processes?

I think that I implement the private, or the subjective, into my work. I ruminate a lot about whether I want something, and what I allow myself and what not. I think that, if you clearly define what is private, deem it to be material, and make use of it accordingly, then you can distance yourself from a kind of voyeurism, which art always is—or at least from mere self-representations. It is surely an important issue nowadays to protect what is private, even though maybe many people have access to my supposedly private life through my public actions.

We spoke before about the format of the exhibition and the extent to which you think of it cinematically. I wanted again to touch upon an aspect of the nature of the work, since I get the impression that your exhibition-displays fundamentally have their own character. Which is not to say that your work is site-specific, but rather to point out that the way you present your work is site-specific. I find this question of (re)presentation exciting, because often certain elements in your work reappear in other constellations and contexts and lead to a new presentation of the work, regardless of the exhibition in which they are connected to each other. Can you say something more about this?

The space or place is often the starting point for an installation. I don't like to work against the space, but rather within its own parameters. I want to know how the

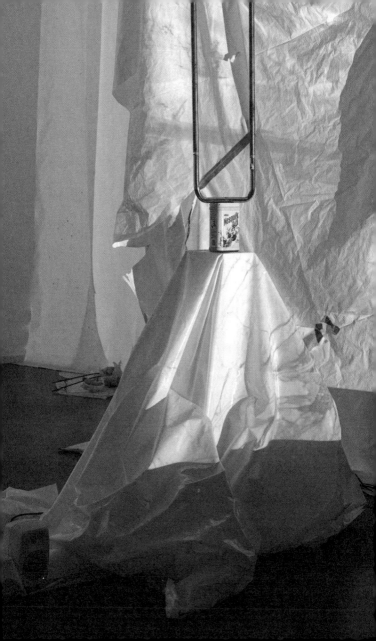

maximum capacity of the space is inscribed in its architecture. But it can also be a question of content. What does the curator particularly like, and what does he or she not like? It's also a process of walking that pushes the boundaries of the tolerable for the institution or for the architecture or for the design.

It's also exciting for me when a space is not a classic "white cube," in which there is nothing, but rather an exhibition space like, for instance, the Kunsthaus Bregenz, which purports to something and leaves a lot of room for the work. The architecture there serves neither as a neutral background in the sense of the white cube nor as something purely autonomous, displaying only its own characteristics. Rather, it oscillates between utility and autonomy, between medium and form. The existing architecture in this sense is extremely important in all of my works, especially when it has this double character: simultaneously a supportive, transporting medium and a competing form of its own that demands an answer.

> This moment, where the presentation of a work acquires its own character, interests me—also with regard to your constant rethinking of different elements from work to work, always arriving at new forms.

Yes, it really is like this. There can, for instance, be student research projects that find a place in an exhibition in order to broaden certain installations or to dissolve certain temporalities, so that one doesn't always proceed with the intention of doing everything anew. For instance, in Bregenz, as part of the exhibition I enlarged the Christmas present that I made for my mother when I was nine years

old—a child's idea of a conceptual art piece, in a way—
multiple times and displayed it on billboards in public
space. I am free to sometimes combine elements or motifs
that are in my archive, but once something is brought
together and exhibited, it really remains always strictly
together as a form. So, it's a bit more strict than arbitrary,
I would say.

> I think of, for instance, the work *In festen Händen*
> (2016) and above all else the continued polyurethane
> sculptures, which function as an almost negative
> volume of bronze sculpture. I'm interested to hear more
> about how you arrived at the further conceptualization
> of this very symbolic lion sculpture—which, of course,
> also stood in originally for a certain taking-over
> of space.

For me, it's about form and volume. I took the image
of the lion because, as you've said, a kind of setting was
already there. As a motif, it's not completely new in my
work, and in this variation another aspect of it is
emphasized. For me, it was about the medium-reflexive
element of sculpture, but also about emptying the
symbolism of an image of a lion—as in, how symbols can
also be used. Think of an outdoor sculpture—what kind
of power does the bronze one have when it is displayed?
Was it the mere shell of the living thing? What is the true
animal in the film in relation to the sculptural
representation? It's about these questions of the facets
that the representations of animal symbolisms can take on.

> You reflect very strongly the different symbolic
> connotations of animals in sculpture, such as the

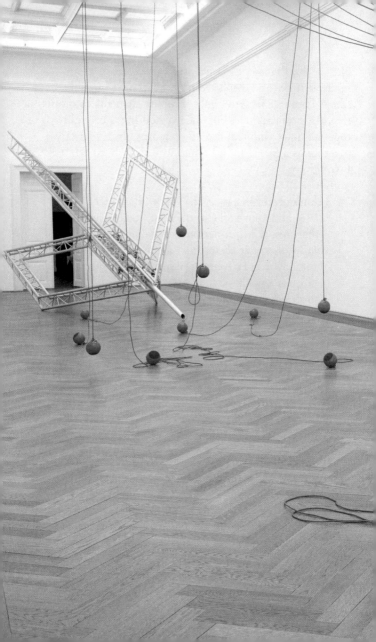

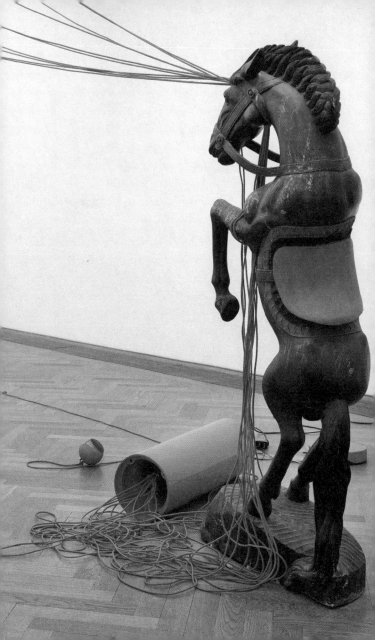

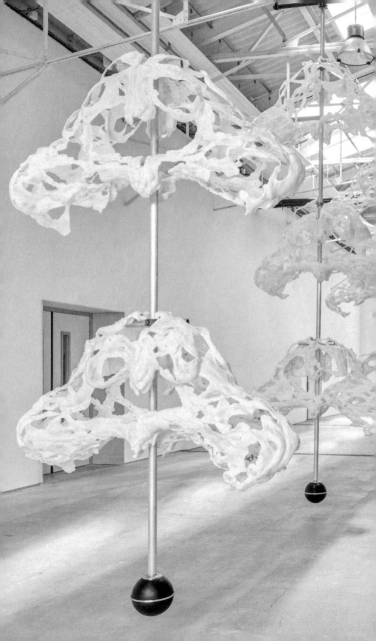

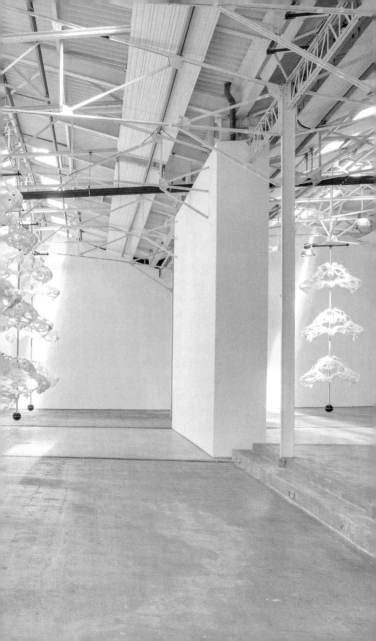

spider, the lion, or the horse, just to name some of the more prominent animals that appear in your work.

There's a more mythological, psychological, or religious element in relation to the spider (think of Tarantism in Southern Italy), a more art-historical one with the lion, and with horses it's more about the representational aspect or the still image, whether it be decoration for façades, equestrian statues, outdoor sculpture, or monumental sculpture.

> Can you go into a bit more why animals occupy such a prominent position in your work even beyond the sculptural, pushing sculpture to its limits, to an understanding of sculpture akin to Rosalind Krauss's in her essay "Sculpture in the Expanded Field"?

On the one hand, it's because I surround myself with animals, because I ride, because I have dogs and because I grew up with a cat, which was almost like a little sibling to me. I would spend the whole day with her, exploring her life. On the other hand, it's because, in the past few years, I've had a stronger interest in the protagonists of films. I wasn't interested in a human persona or an actor, though; rather, I wanted to work with another nonhuman being. So, I initially started with my dog, when we would go for walks in the park. In the Haus der Kunst there was the work *A Woman's Sport Car* (2018), in which a car, while turning, projects out of its headlights, as Rollo [the dog's name] and I walk through the park. The car sees this and continues blinking its lights. That's perhaps my first work involving an animal. No, that's not right; my cat actually appears briefly in another video

work. A few days before she died, I filmed her. I'm
interested primarily in heraldic animals, because I'm
concerned with the moment in which this conventional
symbolism of the animal spills over into something real,
or in which this relationship with the animal (such as
with a pet) transmits something, something almost
abysmal. My animals are rarely taken from what we call
nature, but from culture: from emblems, crests, or coats of
arms—from human semantics attributed to animals.
After having located them there,
I set them free, not to some idealized nature but to
a function they can choose.

> Would you say that your interest in animals eventually
> brought you to paint on leather? How did you arrive
> at such an archaic form of painting? Of course,
> in reality you're painting on synthetic leather.

There are several reasons. On the one hand, I studied
painting, and eventually there was a point in which
I grappled with shaped canvases. I had the problem of not
being able to touch many of the materials that I worked
on, sewed, or glued—they were simply too uncomfortable
for me due to their dryness. So, I switched to leather,
because it's a moist material—haptically, I prefer it to dry
fabrics. This was my practical point of departure.
 Then, in addition, my mother gave me 200 leather skins
from a fabric store that had gone out of business. At the
time I was a vegan and I found it interesting to reflect on
how one legitimizes one's relationship to the materials
one uses—including animal skins.
 It then happened that I used the leather as an image
carrier and put it in relation to a certain discourse about

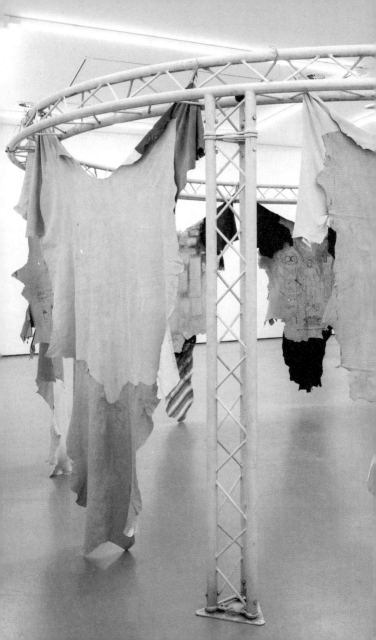

painting, a discourse in which I was socialized and in
which painting had to be conceptually grounded. I was
interested in connecting the constantly evoked endpoint or
purpose of painting, which was always being reformulated,
with the suffering of animals, in the sense that, it could
be said, painting itself is a discourse of suffering. This
is what I wanted to show.

Of course, the form of the leather skin itself also plays
a crucial role, because as a form—i.e., as a triangle—and
as an image carrier it stands in the greatest possible
contrast with the space. In perception theory, an upside-
down triangle is the strongest possible signal in a space.
For example, in my exhibition *My Appropriation of
Her Holy Hollowness* (2021) at Le Confort Moderne in
Poitiers, I put on a bigger installation in which the cross-
bars appear as two giant circles from which the triangles
hang down like panels, and at the De Pont museum I hung
it in a straight line. Over the course of many months,
I collected knowledge—learned, sought-after knowledge.
I named the work *The (Missed) Education of Miss Vogel*.

> What interests me about this work is that, on the one
> hand, you've created a spatial installation—a room-
> display—with these paintings, while, on the other
> hand, these paintings operate like a very personal and
> private "mind map." Can you explain this in a bit
> more detail?

It's a work that addresses knowledge, but also non-
knowledge—knowledge that one doesn't have, that is,
a yearned-for knowledge. I had the need to write down on
very large panels things that I always wanted to know;
I could never remember the dates of the French Revolution

or other sequences of dates, for instance. At the same time, I wanted to connect the work with useless knowledge or specialized knowledge—for instance about dressage, from my old dressage textbook. This sort of mapping makes the displayed knowledge very subjective. Within these mind maps, several historians who engage in a relatively subjective historiography also play a role: take Egon Friedell, who only chooses to study world-historical events that he finds interesting. The work addresses this kind of historiographical subjectivity, but also the habit that artists have of funneling any general knowledge into research art, as I often experienced at the Städelschule in Frankfurt. I have an ambivalent relationship to this, and this is represented here. I present myself on the one hand as interested, on the other as "miseducated."

> As in your other works, it again appears to me that you are creating a kind of relationship of tension here (similar to the aforementioned montage model) in which diverse discourses come into contact with each other: painting, knowledge or its representation, this rather archaic-seeming leather …

I'm always a bit careful with the word "archaic." Though, the crossbars are built in a circular fashion, and it seems as if one were being initiated into something when one steps into the circle—as if one were engaging in a social knowledge ritual. That's why the work may seem a bit magical or archaic. In its most recent version at the De Pont museum, in Tilburg, it is no longer circular.

> I also wanted to touch upon this moment of conflict, which to me seems to be present in the work, such as,

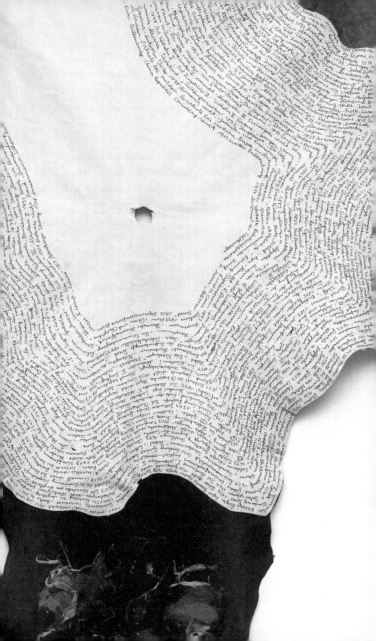

for example, your own dealing with painting,
or the question of privacy and publicness, or rather
the moment in which the private can also become
political.

Or, in addition, to put it in totally concrete terms, cultural
themes from my past that get discussed in the work, such
as knowledge from school, specialized knowledge from
my fine arts studies, or specialized knowledge from riding
or subcultural movements. All of that comes together in
the work, as if the work wanted to answer the question:
"Who, then, is the artist, and what are they reading?"

To conclude, I'd like to touch upon the aspect that
you mentioned earlier: that the sensation of being
under pressure had abated somewhat, or that it had
become transformed. Can you say anything more
about this, from a future-oriented perspective as well?
What do you think has changed in your work or in
your approach as an artist?

I find it exciting to give space to a work that is independent
from its political relations. That's why I didn't want to be
taken in or give too much prominence to certain distinctly
substantive readings (such as a feminist one). But, for
some time now I've been thinking that these political
exchanges and acts of solidarity could become more
interesting, not least because in the past one or two years
a lot has happened in our society. On the one hand, the
decisive political moment of an artistic work is its form,
its jokes, its stance. On the other hand, though, there's
a context and, as far as that's concerned, one should
certainly recognize and permit, for instance, feminist

interpretations. In that sense, I would like to formulate stronger narratives, to change perspectives, and to continue telling strange stories.

And how would you like to tell stories?

I still can't say for sure, but I think it's about a change in perspective. I will continue in a structurally similar way with the means and methods that I have. I should also note that I've had a child, so I've found yet another access point to myself and my role in the world. I think I'm interested in broadening the construction-related principles of my work, keeping the ones already mentioned in this conversation while including new ones that permit more complexity—complexity being the foundation of narrative freedom and the freedom of that which is narrated. I already have a rather ample repertoire: leather, impressions, chrome rods/crossbars and the networks based off of them, ready-mades with enlarging and downsizing effects, the sound and music that is integrated into the installation, videos with different forms of unleashed cameras. In this repertoire there is a lot of freedom to do justice to what happens in the narrative, but now that it's been established for a while now, it could also become functionally more relaxed and opened up.

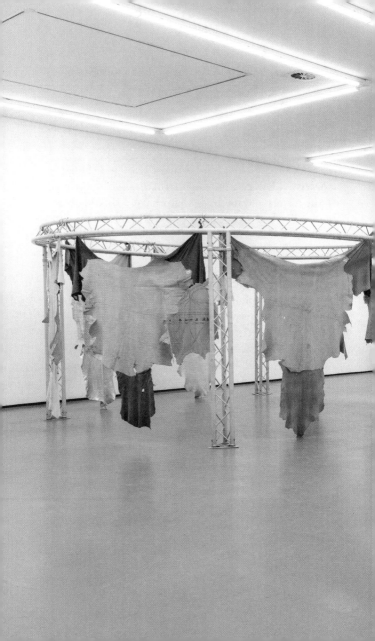

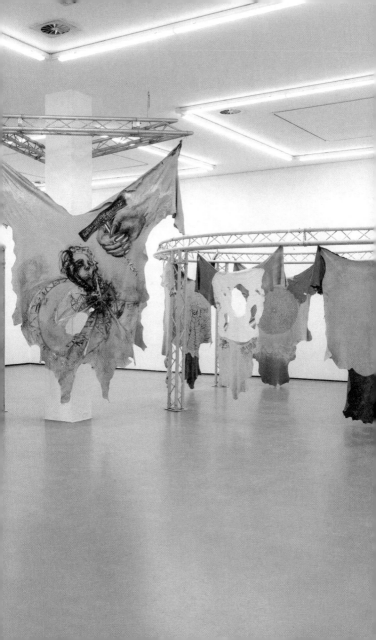

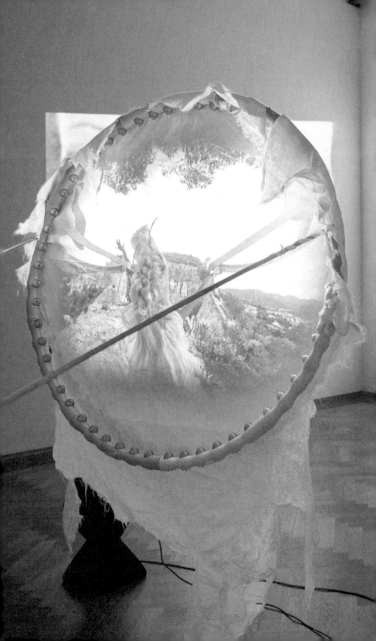

Raphaela Vogel is a Berlin-based artist working primarily in video, installation, and sculpture. She studied at the Städelschule with Peter Fischli and graduated in 2014, and before that studied at the Akademie der bildenden Künste Nürnberg with Michael Hakimi. Her work has been exhibited at, among other places, Kunsthalle Basel, Haus der Kunst in Munich, the Berlinische Galerie, and the 2022 Venice Biennale.

Marie-France Rafael is a tenure-track professor at the Zurich University of the Arts. She studied art history and film studies in Berlin and Paris, and holds a PhD in art history. From 2011 to 2015, she was a research associate at the Free University of Berlin and until 2019 at the Muthesius University Kiel, Department of Spatial Strategies/Curatorial Spaces. Her interview book with French artist Brice Dellsperger, *On Gender Performance* (2019), and her monograph *Passing Images: Art in the Post-Digital Age* (2022) were both published by Floating Opera Press.

p. 4: Raphaela Vogel, *Für Uns*, 2021. Exhibition view, *Paradise Lost*, Kleiner Wasserspeicher, Berlin. Courtesy of BQ, Berlin and the artist
Photo: Roman März, Berlin

p. 7: Raphaela Vogel, *Der Mann, der rückwärts spricht*, 2022. Exhibition view, *Vor der Toren der Sprache*, Galerie Gregor Staiger, Zurich. Courtesy of Galerie Gregor Staiger, Zurich and the artist
Photo: Galerie Gregor Staiger, Zurich

pp. 10–11: Raphaela Vogel, *Der Mann, der rückwärts spricht* (video still, cropped), 2022. Courtesy of Galerie Gregor Staiger, Zurich and the artist
Video still © Raphaela Vogel

p. 14: Raphaela Vogel, *Können und Müssen (Ability and Necessity)*, 2022. Exhibition view, *Mit der Vogel kannst du mich jagen*, Galerie MEYER*KAINER, Vienna. Courtesy of Galerie MEYER*KAINER
Photo: Kati Göttfried

pp. 16–17: Raphaela Vogel, *Können und Müssen (Ability and Necessity)*, 2022. Exhibition view, *Mit der Vogel kannst du mich jagen*, Galerie MEYER*KAINER, Vienna. Courtesy of Galerie MEYER*KAINER
Photo: Kati Göttfried

pp. 18–19: Raphaela Vogel, *Uterusland*, 2018. Exhibition view. Courtesy of Contemporary Fine Arts, Berlin
Photo: Matthias Kolb

pp. 22–23: Raphaela Vogel, *Uterusland*, 2017. Exhibition view, *Produktion: Made in Germany Drei*, 2017, Kunstverein Hannover. Courtesy of Kunstverein Hannover and the artist
Photo: Raimund Zakowski, Hannover

pp. 26–27: Raphaela Vogel, *Uterusland*, 2017. Exhibition view, *Produktion: Made in Germany Drei*, 2017, Kunstverein Hannover. Courtesy of BQ, Berlin and the artist
Photo: BQ, Berlin

p. 29: Raphaela Vogel, *In festen Händen*, 2016. Exhibition view, riesa efau, Motorenhalle, Dresden, 2016. Courtesy of BQ, Berlin and the artist
Photo: Werner Lieberknecht, Dresden

p. 33: Raphaela Vogel, Raphaela Vogel, *Für Uns*, 2021. Exhibition view, *Paradise Lost*, Kleiner Wasserspeicher, Berlin. Courtesy of BQ, Berlin and the artist
Photo: Roman März, Berlin

pp. 34–35: Raphaela Vogel, *Für Uns*, 2021. Exhibition view, *Paradise Lost*, Kleiner Wasserspeicher, Berlin. Courtesy of BQ, Berlin and the artist
Photo: Roman März, Berlin

p. 37: Raphaela Vogel, *Son of a Witch*, 2018. Exhibition view, Berlinische Galerie, Berlin, 2018. Courtesy of Videoart at Midnight
Photo: Maximilian Sprott

pp. 40–41: Raphaela Vogel, *Son of a Witch*, 2018.
Exhibition view, Berlinische Galerie, Berlin, 2018.
Courtesy of Videoart at Midnight
Photo: Maximilian Sprott

p. 44: Raphaela Vogel, *Mogst mi du ned, mog i di*, 2014.
Exhibition view, *Raphaela und der große Kunstverein*,
Bonner Kunstverein, Bonn, 2015. Courtesy of BQ, Berlin
and the artist
Photo: Simon Vogel, Cologne

pp. 46–47: Raphaela Vogel, *Mogst mi du ned, mog i di*,
2014. Video still, Bonner Kunstverein, Bonn, 2015.
Courtesy of BQ, Berlin and the artist
Photo: Simon Vogel, Cologne

p. 49: Raphaela Vogel, *Mogst mi du ned, mog i di*, 2014.
Exhibition view, *Raphaela und der große Kunstverein*,
Bonner Kunstverein, Bonn, 2015. Courtesy of BQ, Berlin
and the artist
Photo: Simon Vogel, Cologne

pp. 52–53: Raphaela Vogel, *Uterusland*, 2018. Exhibition
view, *Ultranackt*, Kunsthalle Basel, 2018. Courtesy of
Kunsthalle Basel
Photo: Philipp Hänger / Kunsthalle Basel

pp. 54–55: Raphaela Vogel, *My Appropriation of Her
Holy Hollowness*, 2021. Exhibition view, Le Confort
Moderne (F), Poitiers, 2021. Courtesy of Galerie Gregor
Staiger Zurich and the artist
Photo: Pierre Antoine

p. 58: Raphaela Vogel, *The (Missed) Education of Miss Vogel*, 2021. Courtesy of BQ, Berlin and the artist
Photo: Roman März, Berlin

p. 61: Raphaela Vogel, *The (Missed) Education of Miss Vogel*, 2021. Courtesy of BQ, Berlin and the artist
Photo: Roman März, Berlin

pp. 64–65: Raphaela Vogel, *The (Missed) Education of Miss Vogel*, 2021. Exhibition view, *Carnivalesca – Was Malerei sein könnte*, Kunstverein in Hamburg, 2021. Courtesy of BQ, Berlin and the artist
Photo: Fred Dott

p. 66: Raphaela Vogel, *Fruit of the Hoop*, 2018. Exhibition view, *Ultranackt*, Kunsthalle Basel, 2018. Courtesy of Kunsthalle Basel
Photo: Philipp Hänger / Kunsthalle Basel

Cover: Raphaela Vogel, *Fruit of the Hoop*, 2018. Exhibition view, *Ultranackt*, Kunsthalle Basel, 2018. Courtesy of Kunsthalle Basel
Photo: Philipp Hänger / Kunsthalle Basel

Colophon

Copyediting: Jude Macannuco
Proofreading: Julie Astor
Graphic design: Supercomputer
Reproductions: Falk Messerschmidt
Printing: PögeDruck Leipzig

© 2023 Floating Opera Press,
and the authors

© 2023 for the reproduced works by Raphaela Vogel:
the artist

Published by
Floating Opera Press
Hasenheide 9
10967 Berlin
Germany

ISBN: 978-3-9823894-5-5

Printed in Germany